2.50

FIRE FROM THE SKY

Salvadoran Children's Drawings

Foreword by Edward Asner
Introduction by Dr. Charlie Clements
Afterword by Dr. Robert Coles

Edited by William Vornberger

Writers and Readers Publishing Cooperative
New York

Writers and Readers

**Writers and Readers Publishing Cooperative,
Incorporated**
500 Fifth Avenue, New York, NY 10110

Copyright © 1986 William Vornberger
Foreword Copyright © 1986 Edward Asner
Introduction Copyright © 1986 Charlie Clements
Afterword Copyright © 1986 Robert Coles
Photographs Copyright © 1986 with
individual photographers

Printed in Italy
First printing May 1986.

Design by David Willoughby.
Cover Design by Janet Koenig.

Library of Congress
Cataloging-in-Publication Data

Fire from the sky.

1. Children's art—El Salvador. 2. El Salvador in
art.
3. El Salvador—Politics and government—1979-
—Pictoral works. 4. War in art.
I. Vornberger, William.
N352.F48 1986 741.9'088054 86-13246
ISBN 0-86316-124-3 (HRD.)
ISBN 0-86316-123-5 (PBK.)

Many different people helped make this
book possible; so many in fact that their names
would fill an entire page. To everyone who
helped, even in the smallest way, I would like to
offer a heart-felt thank you. A very special thank
you to Ed Asner, Charlie Clements and Robert
Coles for your moving and powerful written
contributions. Thank you B. Lynne Barbee, Ann
Shields, Mike Fonte, Kathy McNeely, David
Albert, and Jolie Stahl for your support and
hours of criticism and encouragement. Thanks to
Tamara Guyton, Anne Hess, W. H. and Carol
Ferry, Steve Brown, Abby Rockefeller, without
your help this book would not be possible. Thank
you David Willoughby for your patience and fine
work and Independent Design for contributing
the typesetting. Thank you to Americans for
Peace in the Americas for sponsoring and
supporting this project. A special thanks to
Solidarity Publications for use of material from
their book "Forced To Move" by Renato
Camarada.

Finally, thank you to the Salvadoran
people who, in the midst of so much pain and
suffering, showed me so much kindness and
goodwill. Your struggle will not be in vain.

A portion of the proceeds from the sale of this book
will go to provide medical and humanitarian aid for
victims of the war in El Salvador.

DEDICATION

This book is dedicated to the people, and especially the children, of El Salvador who are struggling, working, and hoping for peace and justice in their country.

ABOUT THE DRAWINGS

The drawings in this book are by Salvadoran children between the ages of eight and fourteen living in refugee camps in Central America. Many of these children have not left the camps for over five years. They did the drawings in school as a form of "play therapy" which enabled them to express feelings and memories that normally have no outlet.

C O N T E N T S

F O R E W O R D Edward Asner page 7

I N T R O D U C T I O N Dr. Charlie Clements page 11

T H E M A S S A C R E page 15

T H E A I R W A R page 29

T H E F L I G H T page 43

T H E R E F U G E page 55

A F T E R W O R D Dr. Robert Coles page 63

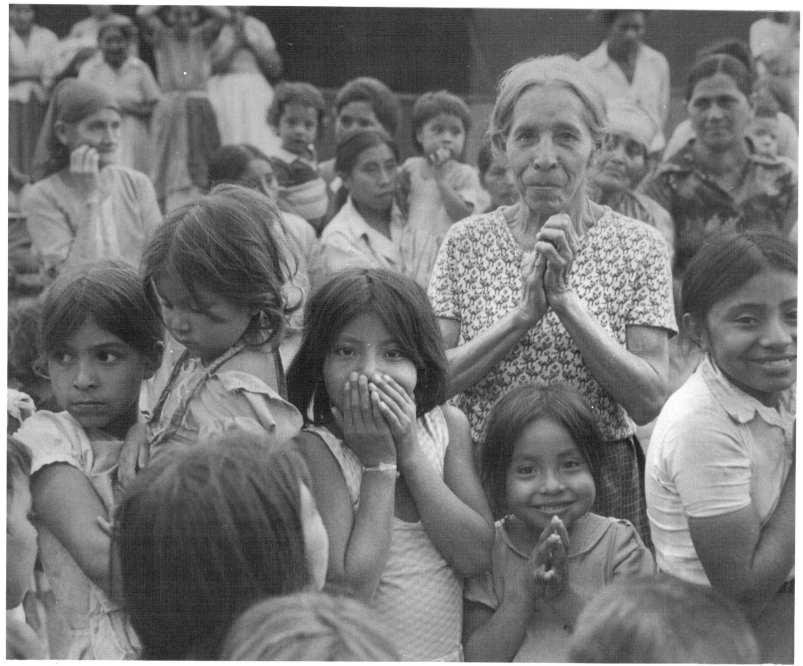

B. Lynne Barbee

F O R E W O R D

When I first publicly questioned U.S. involvement in El Salvador, our government's role was less visible than today. At the time, I knew my position — that other countries should have the right to self-determination without U.S. military intervention — was not widely accepted or practiced. I thought that the best way to get people's attention was to work to send humanitarian aid to El Salvador. So I helped a group called Medical Aid for El Salvador send medical supplies to the thousands of people wounded in the civil war; a war that, up to that point, had killed 30,000 people.

But things have changed since then and so has my position. The death toll has doubled; there are now 60,000 Salvadorans dead from the war. The Salvadoran government's tactics have also changed: they have received sophisticated aircraft from the U.S. and are using it to deadly ends. A bomb dropped from 2,000 feet can't tell the difference between adults and children. Children can't run to the air raid shelter as fast as adults so they are often caught in the open. Many children have died as a result of the government bombings. So many that the

aircraft have been nicknamed "the flying death squads." This reality in El Salvador has made it impossible for me to remain silent.

In one sense it would have been easy to remain neutral and away from the controversy because working to send humanitarian aid takes the moral high ground and is not easily criticized. But I could not. I couldn't because it is my government that is sending the helicopters, the bombers, the machine guns. It is my tax dollars, and yours, that pay for the bullets, bombs, and the machetes that are killing the people shown in these drawings.

Over two billion U.S. tax dollars have gone to support the war in El Salvador while health care and education in this country are declining and poverty among young children is on the rise. Maybe we should worry less about our "national security", build fewer bombs, and think more about the security of our children. Maybe we should worry less about the "communist menace" and think more about the menace of poverty, disease, and death that affects so many young people's lives.

I recently saw a documentary called "Captive in El Salvador." A 9 year-old girl who lived in a refugee camp matter-of-factly told of her father's murder at the hands of the death squads. She also described the soldiers standing outside the camp, waiting for the "subversives" to try to leave so they could make them "disappear." The interviewer, an Israeli journalist named Ofra Bikel, asked "what is a subversive" and the girl answered, "I believe that a subversive is someone who tells the truth and stands up for his rights."

We should learn from this young girl in El Salvador. Children have no ideologies and their minds are not dulled by the same old formulas that haven't worked for adults. Yet, we are their teachers and they look to us for guidance. We must never forget the great responsibility we have for our children.

Pablo Casals put it very well when he wrote: "What do we teach our children in school? We teach them that two and two make four and that Paris is the capital of France. When will we teach them what they are? We should say to each of them . . . 'In all the world there is no other child exactly like you. You have the capacity for anything . . . and when you grow up, can you harm another who is like you, a marvel? You must work to make this world worthy of its children.' "

Fire From The Sky reminds us that we have not lived up to our responsibility and have failed to make a part of this world worthy of its children. The children of El Salvador have lived what we try so desperately to keep from our kids — hunger, fear, pain, death. We have a great deal to learn from this artwork. The authors of these drawings should be our teachers and we their students. I hope that the scenes depicted in these drawings will motivate you to work to end the war in El Salvador and make our planet worthy of all its children and especially the children of El Salvador.

Edward Asner
September, 1985

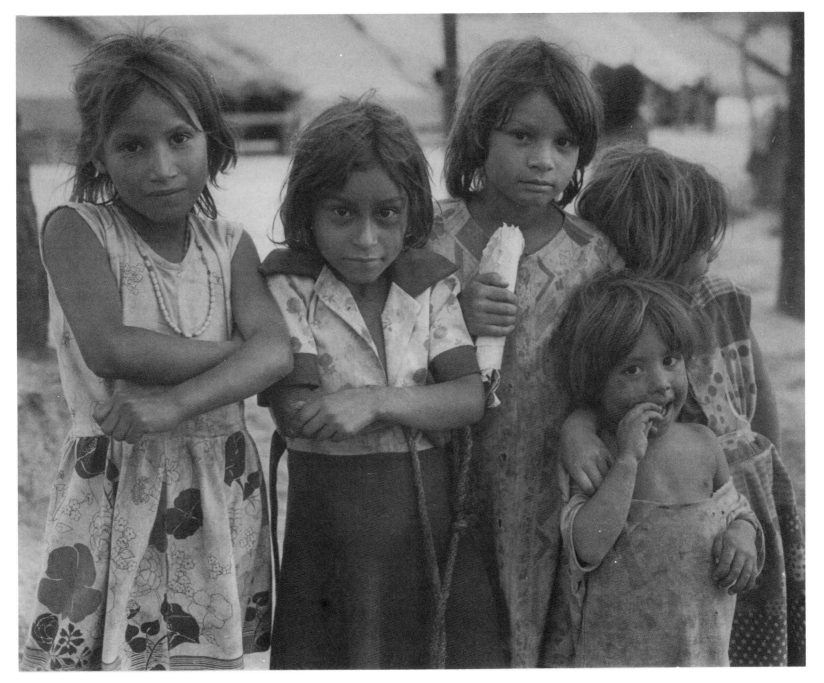

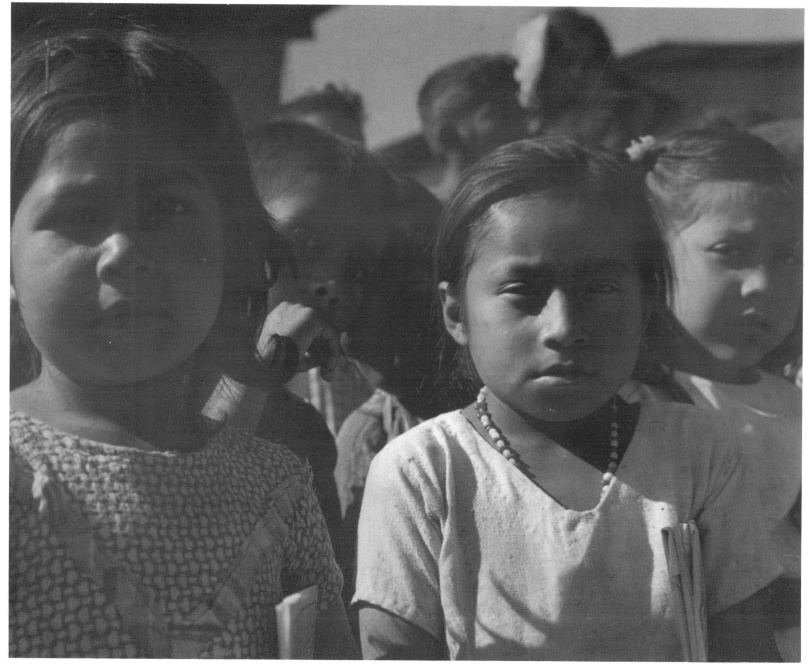

B. Lynne Barbee

I N T R O D U C T I O N

It was a small room, maybe measuring 20 by 30 feet. Normally 14 of us slept there. On one small wooden bed strung with home-made hemp, three children slept head to toe or in tangled heaps of arms and legs. Others including myself and the youngest boy Antonio, slept on the floor. In the rainy season he would prefer to crawl into the single hammock with his mother and baby sister. On nights when he or one of the other children suddenly woke up screaming, their elderly aunt would quietly get up and carry them to her pallet on the floor and quiet their cries. The sounds of scurrying rats, the irritating buzz of mosquitos, and the not too distant echoes of war, were shadowed by the children's fitful sleep in that rural Salvadoran home.

It would be months before I actually saw the images that lay behind the children's nightmares. One day Antonio and his sister Olivia asked me for sheets of paper from my medical notebook. In minutes they had completed shockingly vivid drawings of helicopters strafing, jets bombing, and soldiers killing – all interspersed with ghostly figures of the victims. They were the images of children whose reality was "search and destroy missions", "free-fire zones", and "fire from the sky" (napalm and phosphorus bombs). They had fled an army that regularly raped, tortured, or killed civilians they considered to be subversives by virtue of living in an area of military conflict.

Though paper was scarce, I would see these drawings again and again — sometimes etched on the side of a grain-storage bin with a piece of limestone or scratched on the paper lining from a pack of cigarettes. These are the same images that Bill Vornberger has so poignantly portrayed in **Fire From The Sky**. They tell the tragedy of El Salvador better than any adult's images or words ever could because they have the directness and innocence that only a child can project.

After an absence of more than two years I returned to El Salvador, hoping to see some of the children who knew me as the 'gringo doctor' when I lived with them. I also wanted to discover the truth about the air war, the existence of which the U.S. embassy categorically dismisses. A typical incident

pictured in this book occurred during that visit to El Salvador. A woman and her three children were killed by an A-37 attack on a town just outside San Salvador. The U.S. Embassy has denied the incident ever occurred as it does most others. The road-blocks set by government troops prevented the press from reaching the scene and hence documenting what is a daily occurrence in many parts of El Salvador. If Bill Vornberger were to travel to that town and ask the children to draw what they had lived through we would witness a truth that forcefully contradicts the practiced denials of the U.S. Embassy.

Many rural Salvadorans continue to suffer horribly at the hands of the armed forces. The silence of the Western press isn't an anomaly as reporters are often denied access to recently attacked areas. Salvadoran military officials have told Western reporters that ''the press lost the war for you in Vietnam and we won't let that happen here.'' As this book goes to press the most extensive and intensive aerial warfare in the history of the Western Hemisphere is being waged by U.S. supplied air-

craft; A-37 fighter bombers whose 500 lbs. iron bombs have fuse extenders which detonate them three feet above the ground, spraying shrapnel for hundreds of yards. AC-47 aircraft are equipped with armour piercing .50 caliber machine guns whose bullets can easily penetrate the bomb shelters in which the children hide. There are also Hughes 500 helicopters equipped with night vision scopes and electronic gattling guns which can put a bullet in every square foot of a football field every 60 seconds. Finally, there are American-piloted AC-130's providing target intelligence with infra-red scopes that detect the heat of human bodies from 10,000 feet but do not distinguish between guerrillas and civilians or children and adults. Thus the vivid images in this book provide evidence and testimony to today's aerial warfare in El Salvador — testimony most Americans will not see in their local newspaper or on television.

The question I've asked myself since working in El Salvador, and which will be on your minds after reading **Fire From The Sky**, is how will these children be affected by the trauma of this war. My

recent visit allowed me to see adults and children who had fled their homes in the country for a small refugee camp in San Salvador. Over 1,500 refugees now live in an abandoned soccer stadium in the capital. Some of the children were recent arrivals and the pictures they drew were not unlike those in this book. Other children who had lived in the camp for as long as two years — away from the bombings and the soldiers who "disappear" people — drew pictures filled with birds or sunshine and flowers.

The pictures still have the images of death and destruction, but those scars seem to be diminishing. It gave me great hope. Most encouraging though was a part of the Salvadoran character that we discovered in that tiny, tragedy-filled camp. The members of our delegation were struck by the lack of hatred or bitterness. Despite all that had happened to the refugees, surely more horror than any of us can comprehend, there remains a vision of a future in El Salvador with justice and peace. Their faith and courage in the face of so much adversity is being passed on to their children and should serve as an inspiration to us.

This book does not explain the roots of the conflict in El Salvador today. Neither does it explore the context for a settlement. However, if the violence in these drawings disturbs you, then I hope you will seek to understand both the poverty and oppression which are the causes of this civil war. Until we understand the violence to the spirit that comes from watching your child die needlessly of malnutrition, there can be no insight into the desperation that leads a peasant to pick up a rifle and fire at a multi-million dollar jet fighter bomber. Only with this kind of understanding will we be able to find lasting solutions to this and other inevitable revolutions in Central America.

Dr. Charlie Clements, M.D.
author of *Witness to War*

President
Americans for Peace in the Americas
Washington, D.C.

THE MASSACRE

In Spanish, "la matanza" means "the massacre" but in El Salvador it has a different meaning. "La Matanza" refers to the bloody three week period in 1932 during which the military killed 30,000 Salvadorans. General Hernandez Martinez, president of El Salvador, ordered the massacre as a reprisal for a peasant uprising in which impoverished Salvadorans, suffering from the effects of world-wide depression, tried to take land from the wealthy landowners.

The massacre of 1932 was the forerunner of many to follow but the vivid memories of "La Matanza" forced a fearful calm over the country for 40 years. The Salvadoran government failed to address the causes of the uprising--namely poverty--instead it silenced the poor.

In December of 1977, following an election marked by fraud, intimidation, and violence thousands of Salvadorans took to the streets to protest the "victory" of General Humberto Romero. A massive demonstration began in downtown San Salvador's Plaza Libertad and the plaza was occupied by demonstrators for several days. The protest ended when the military and para-military death squads surrounded the demonstrators and attacked. When the attack ended, 200 people were dead.

On January 22, 1980 200,000 Salvadorans marched in the capital to mark the 48th anniversary of the 1932 uprising and massacre. Military sharpshooters on the rooftop of the national palace opened fire on the crowd, killing 21 and wounding 180 others. Prior to 1980 most of the repression was confined to the urban areas but as the war spread to the countryside the civilians living there suffered terribly.

In May, 1980 on the banks of the Sumpul river, the Salvadoran military killed over 600 refugees as they tried to reach safety on the Honduran side of the river. Senator Edward Kennedy entered this testimony, taken from the survivors of the massacre, in the Congressional Record: ". . .On the opposite side [the Salvadoran side of the river], at around 7 a.m., in the village of La Arada and its surrounding area, the massacre began. A minimum of two helicopters, the Salvadoran National Guard, soldiers and the para-military organization ORDEN opened fire on the defenseless people. Women tortured before the finishing shot, infants thrown into the air for target practice, were some of the scenes of the criminal slaughter. The Salvadorans who crossed the river were returned by the Honduran soldiers to the area of the massacre. In mid-afternoon the genocide ended, leaving a minimum number of 600 corpses."

In Morazan province, between December 7th and the 17th, in 1981, the army lead by the U.S. trained Atlacatl battalion, as part of a pacification effort, conducted a "counter-insurgency" sweep. In the nine villages that were "pacified" the military killed almost 1,000 people. The collective slaughter became known as the "Mozote Massacre" because in that village alone 482 were killed, 280 of which were children under the age of 14.

Children who saw and lived to recall these and similar events drew the images in this section. Many children, like the children of Mozote, did not.

"The armed force massacres the peasants. They go out running through the woods and go shooting at them and they go falling dead. They don't let peasant people live. They kill young people and children and old people and until they kill enough people."

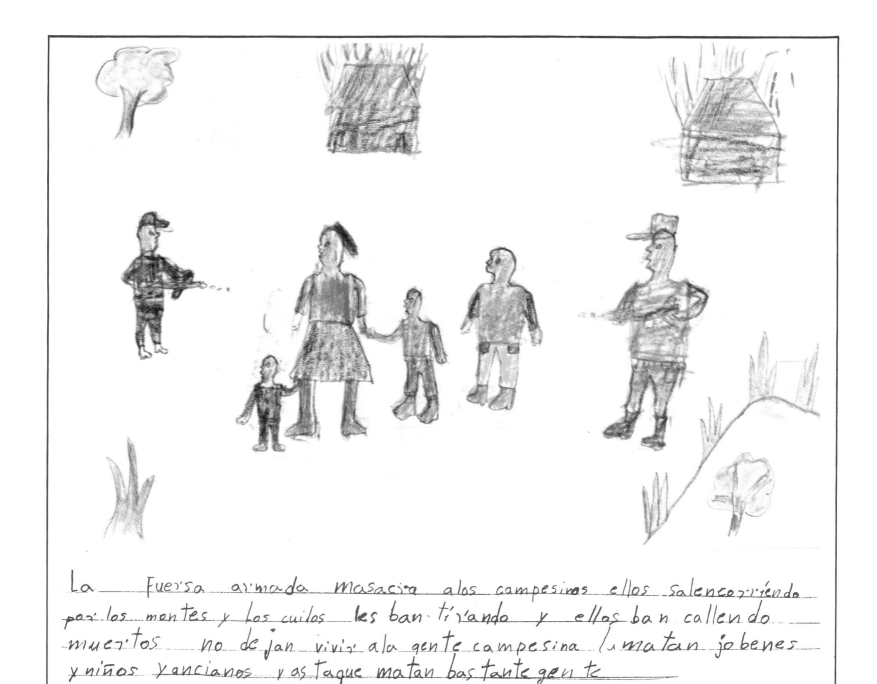

La fuersa armada masacra alos campesinos ellos salencorriendo par los montes y los cuilos les ban tirando y ellos ban callendo muertos no dejan vivir ala gente campesina lumatan jobenes y niños yancianos y as taque matan bastante gente

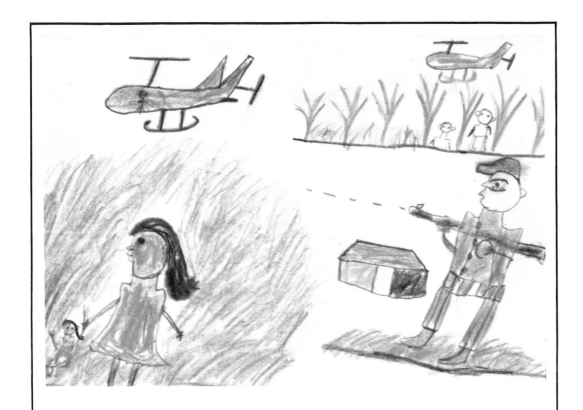

cstos Soldado entran a lantom para masacrar a nuestra yente les queman las Casas y elyos cuandos los ven se Van a Fuir a los montes a los bosque talbes sin comer y Sufriendo sed.

W. Vornberger

"These soldiers came into Lanton to massacre our people. They burn their houses and when they see the soldiers they flee to the mountains to the forest maybe without eating and suffering from thirst."

La situación en el Salvador es imcomparable. por que hai descabeJan niños y despues los queman. haci como aparecen en la Grráfica.

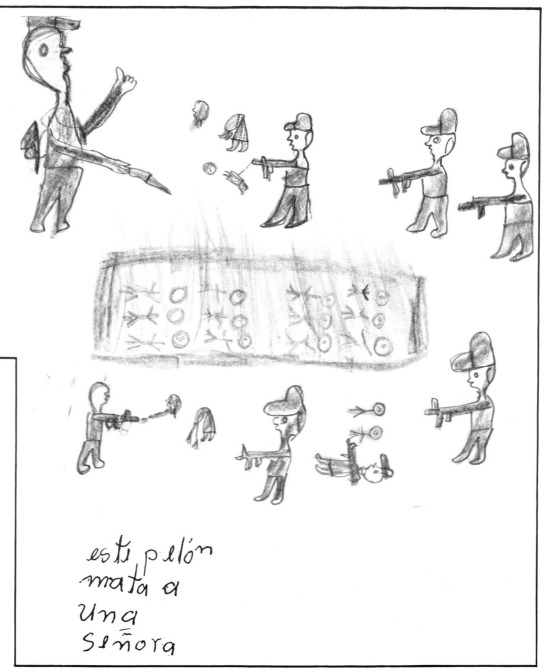

"The situation in El Salvador is unique because they behead children and then they burned them. Just like it shows in the picture.

"The skinhead is killing a woman."

esti pelón mata a una señora

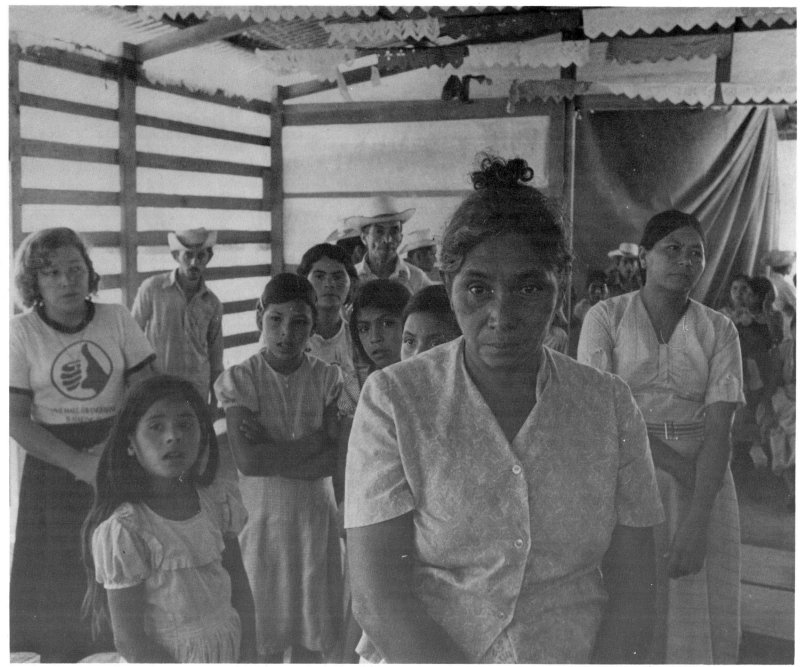

B. Lynne Barbee

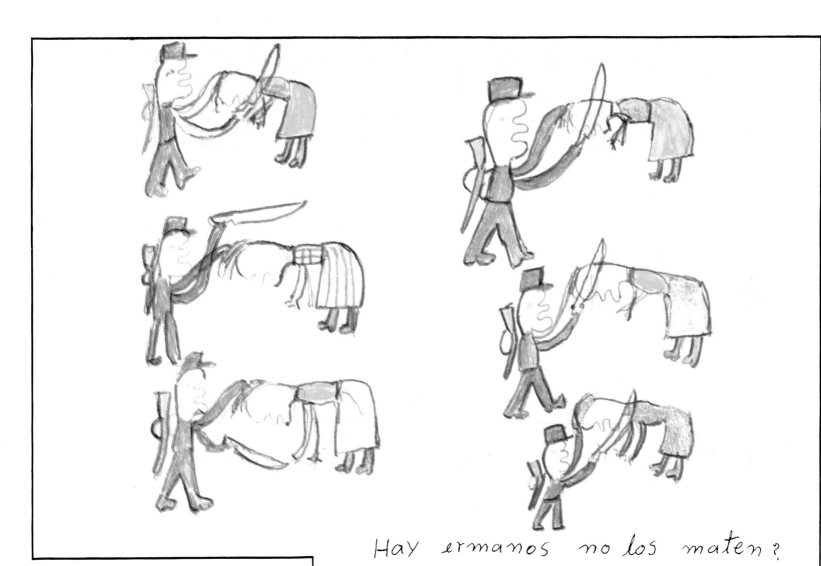

"Oh brothers don't you kill us.
Shut up you whores, you are
guerilla's wives. Sharpen those
machetes for the heads of
these women."

Hay ermanos no los maten?
Cayense putas ustedes son mujeres
de Guerrilleros Filo ha esos machetes
para des cabeza ha esas mujeres.

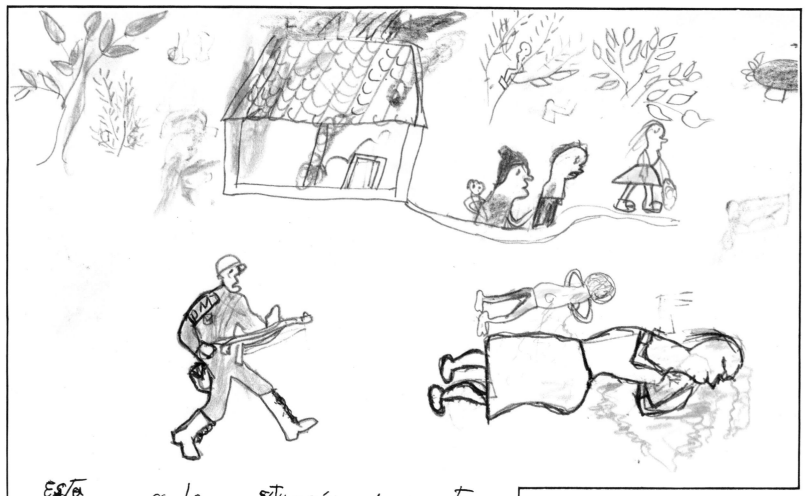

Esta es la situación de nuestro paiz los de la fuersas armadas nos estan asesinando a todos nuestros hermanos aseeinan todos por Igual nos asecinan niños mujeres y ancianos.

"This is the situation in our country. The people in the armed forces are killing all our brothers. They murder everyone equally, they kill us all, children, women, and old people."

Jueves 13 de octubre de 1983
ESTo es lo que hace
La fuerza armada
con los campesinos
Saluadoreños mantan
los niños que man
las casas mantan
los animales sancan
los campesinos de las casas
amatanlos esto hacen
las fuesas armada
con los campesinos
del Saluador.

Thursday, October 13th, 1983
"This is what happened with the
armed forces and the Salvadoran
campesinos. They killed the children
who were in the houses. They killed
the animals. They took the
campesinos from their houses and
killed them. This is what happened
with the armed forces and the
Salvadoran campesinos."

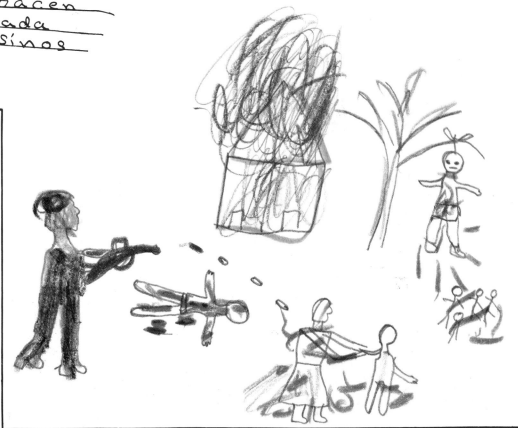

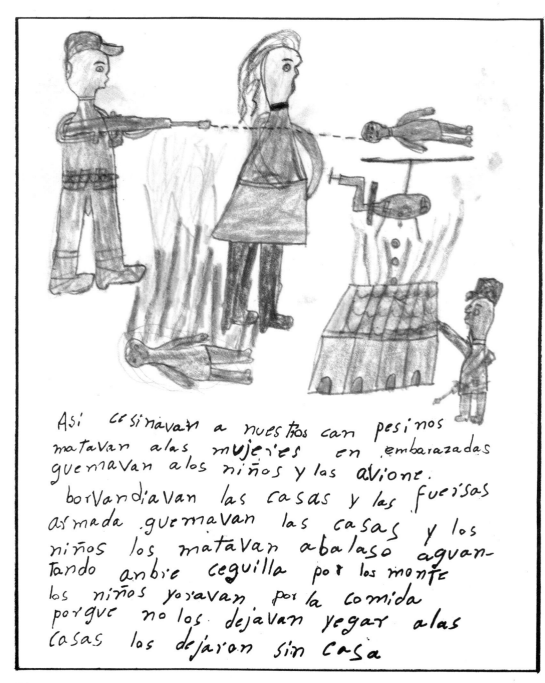

Asi cesinavan a nuestros can pesinos
matavan alas mujeres en embarazadas
guemavan a los niños y las avione.
borvandiavan las casas y las fuersas
asmada guemavan las casas y los
niños los matavan a balaso aguan-
tando anbre ceguilla por los monte
los niños yoravan por la comida
porgue no los dejavan yegar alas
casas los dejaron sin casa

"This is how they killed our
campesinos. They killed the
pregnant women and they burned
the children and the planes bombed
the houses and the armed forces
burned the houses and they shot the
children. Suffering from hunger they
fled to the mountains and the
children were crying for food
because they didn't let them go
home. They left them homeless."

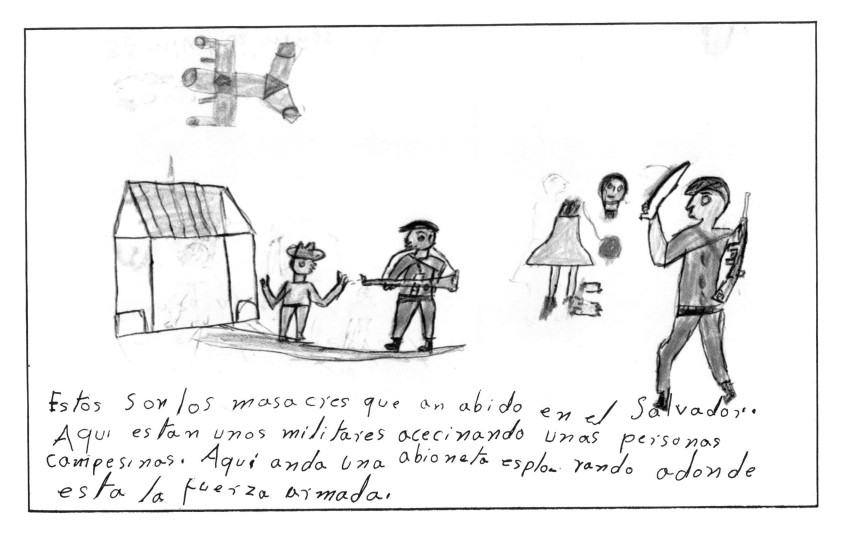

Estos son los masacres que an abido en el Salvador..
Aqui estan unos militares acecinando unas personas
campesinos. Aqui anda una abioneta esplorando adonde
esta la fuerza armada.

"These are the massacres that have taken place in El Salvador. Here are some soldiers killing some campesinos. Here is a small plane looking for where the armed force is."

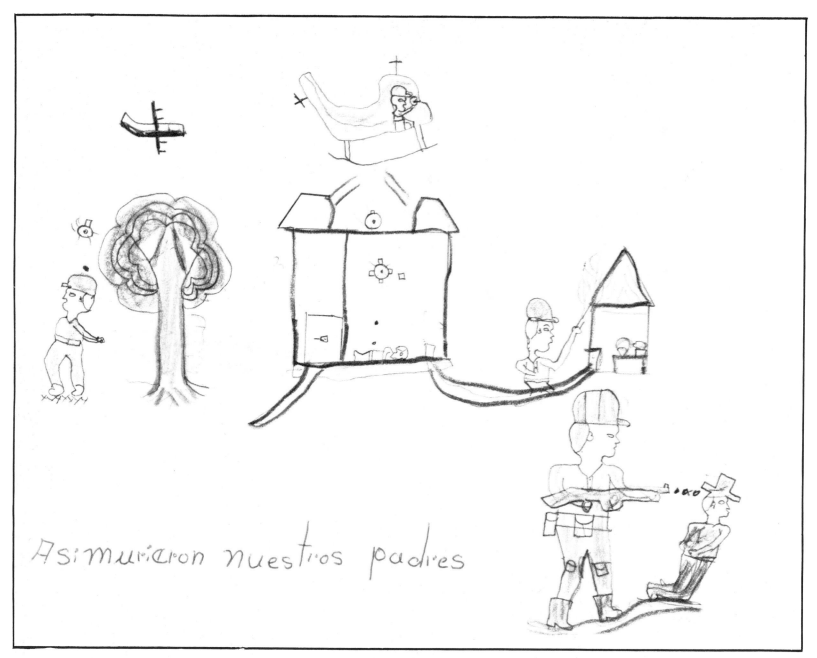

"This is how our parents died."

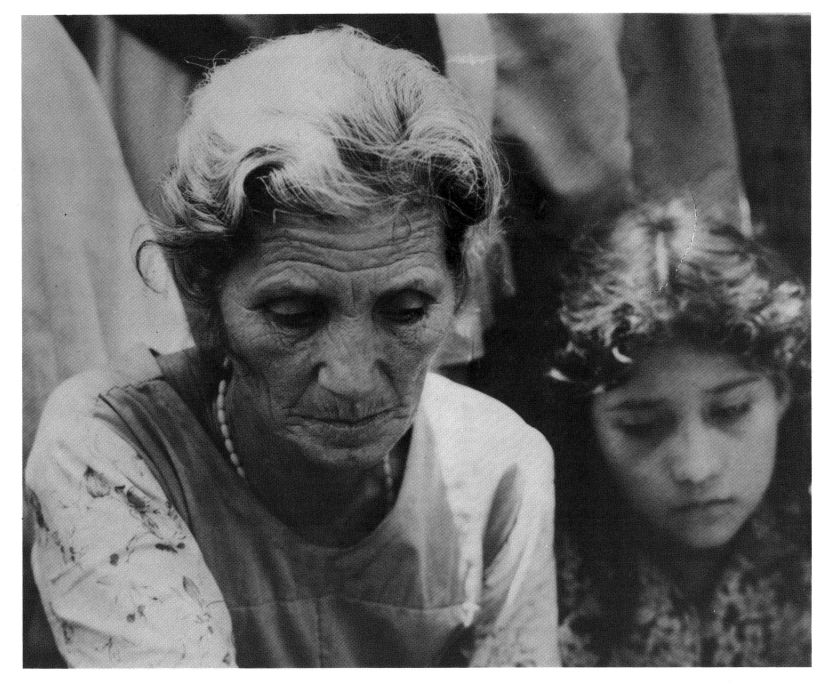

T H E A I R W A R

The drawings in this section show the horror and destruction caused by the airwar in El Salvador. The Salvadoran airforce receives almost all of its training and equipment–including helicopters, bombers, phosphorous rockets, and iron bombs–from the United States. U.S. instructor pilots have accompanied the Salvadorans on bombing missions. The U.S. airforce also conducts reconnaissance flights over El Salvador to provide the Salvadoran airforce with targetting information.

The Salvadoran airforce now attaches "fuse extenders" onto the ends of iron bombs. The bombs explode three feet off the ground, making them more effective anti-personnel weapons since previously much of their explosive power was lost on adobe houses. Now anyone struck by these flying shards is maimed or killed. The airforce also has used napalm and phosphorus rockets against the civilian population, leaving severe burns for which there is no treatment in rural El Salvador.

A medical delegation, including a burn expert from Harvard University, reported: "...incendiary substances dramatically consistent with jellied gasoline (napalm) were repeatedly described to us by eyewitnesses including the charecteristic elongated burned strip of land left behind...Dr. [John] Constable was able to confirm injuries consistent with napalm use on a woman and her two children."

A woman who survived an attack by incendiary weapons testified "I was outside my house when the bomb fell. I could not see any thing because of the black smoke and could not get air. Everything was on fire. My two children burned to death."

It is clear that the Salvadoran military is carrying out a campaign of indiscriminant bombing against an unarmed civilian population. It's purpose is to drive people from their homes and deny the insurgents a base of popular support. The military often burns crops which forces people to leave because of hunger. This campaign has caused a full 25% of the Salvadoran population to flee their homes. In the U.S. that would be the equivalent of over 60 million Americans.

Representative Frank Annuzio (D-IL) entered this testimony about the airwar into the Congressional record in December, 1985: "For most Salvadorans today, there are two facts of life: desperate poverty, and the war. For the people of El Salvador the war threatens them on two fronts: the airwar and bombardment which the United States supports and makes possible, and the police surveillance which we now propose to escalate. Every helicopter we send to El Salvador is a potential gunship. Thousands of peasants are living in underground holes during the daylight hours in order to escape the bombing. At night they hide from the army patrols and the security forces...Hunger, disease, and broken families are what our policy has guaranteed for thousands of Salvadorans."

The airwar has resulted in thousands of civilian deaths and countless suffering by the survivors. The drawings in this section only begin to portray life in rural El Salvador under constant attack by the army and airforce. It is clear why one million Salvadorans have taken to flight — to escape the bombs and bullets of the war.

"This is life in El Salvador. These are planes that bombarded the houses of us the campesinos. Here we see that we campesinos are murdered by the military. Our bodies are tossed on the ground just like that and our campesinos are eaten by the animals."

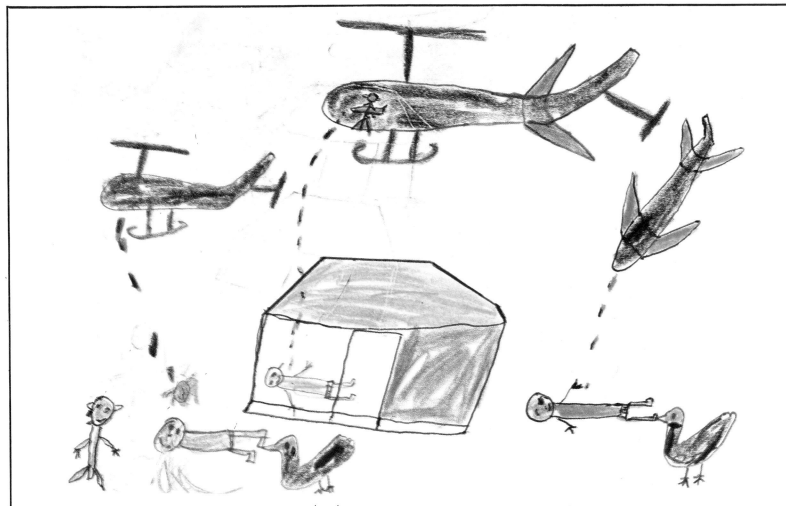

esta es la vida del Salvador. esos son los aviones
que borban dea nuestras casas de los campecinos aqui vemos
que nuestros campecinos estan acecinados por los militares
nuestros cuerpo estan tirados asi a la tierra y nuestros
campecinos son comidos de los animales.

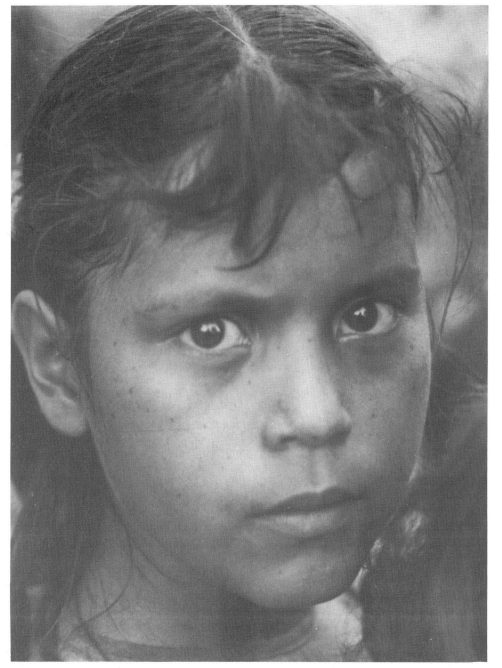

Renato Camarada

soy un niño Refugiado
nos amos venidos
de El salvado porque
nos querian matar Los
cuilios acesinaron a
nuestros niños ancianos
mataron A nuestros
ermanos hemos
Aguantamos tormentas
y nos hemos venidos
del salvador porque
teniamos miedo que Los
mataron y doy grasias
a Dios todabilla estoy
vivo en El Refugio

"I am a refugee boy.
We came from El Salvador because
they wanted to kill us. The civil guards
assasinated the children and the old
people. They killed our brothers. We
have endured torments and we came
from El Salvador because we were
afraid that they would kill us and I
thank God that I am still alive in the
refugee camp."

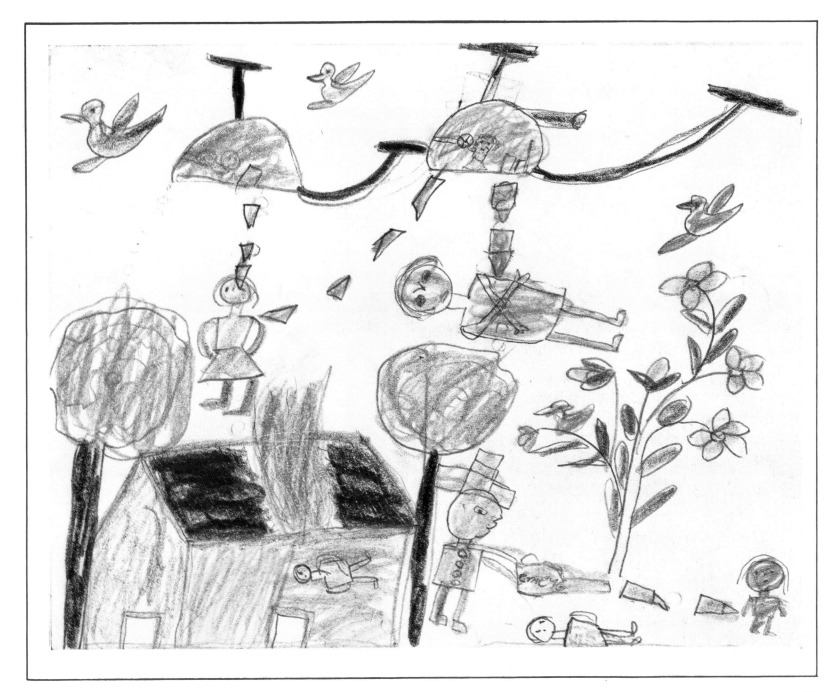

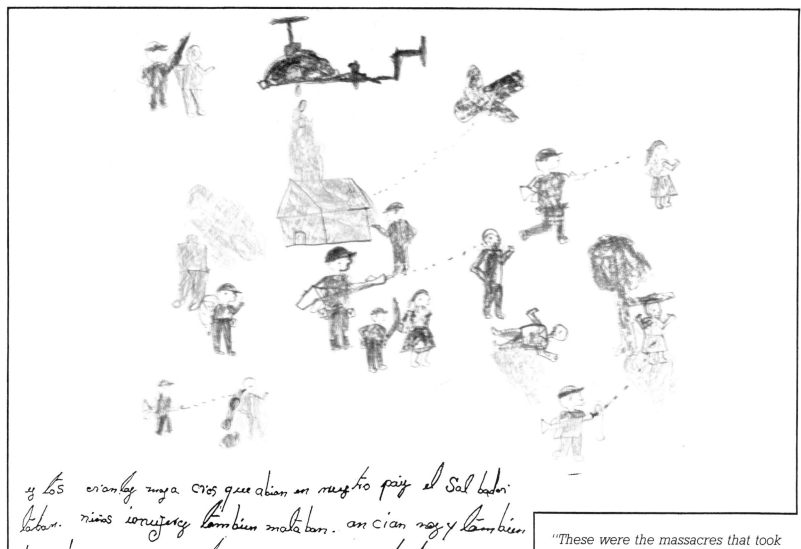

y los criantas maya crios que abian en nuestro pais el Salbador
taban. niños imugeres tambien mataban. ancian nos y tambien
hor caban ancianos y las ayuon gufrir. anbisaban aguan
taban. tormentos y aguan taban anbre barias.
niños ivemorian niños de anbre y degcia.

"These were the massacres that took place in our country El Salvador. They killed children and women. They also killed old people and they lynched them and made them suffer. They were hungry, they endured torture and endured hunger, some of them. Children died of hunger and thirst."

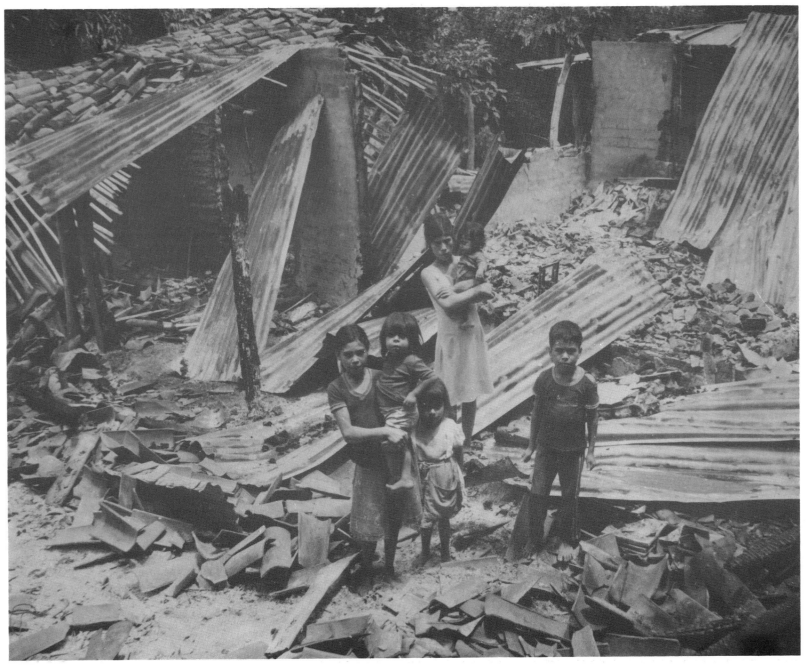

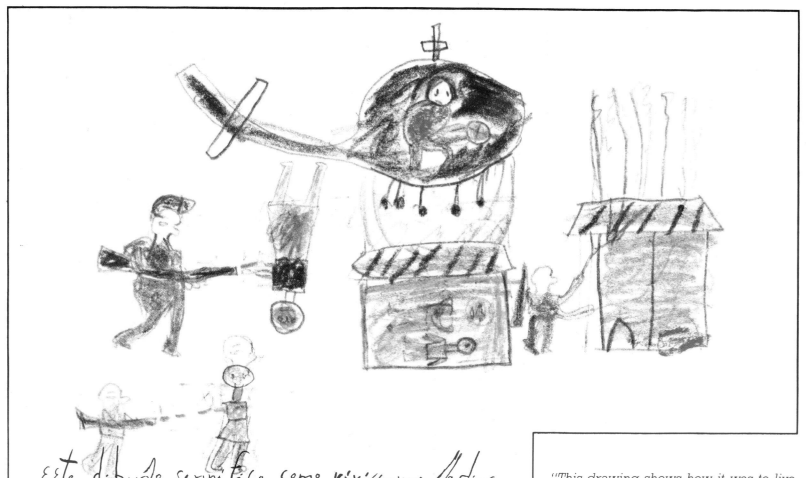

Este dibujo serimifica como vivíamos ha dias En nuestro Paíz. Poreso nosotros los venimos de nuestro Paíz porque los gulrillos matas. Y Porque no los mataran atodos. Mejor lo venimos para ca.

"This drawing shows how it was to live in our country. This is why we left our country because they wanted to kill us and they didn't kill everyone.

"Better that we came here."

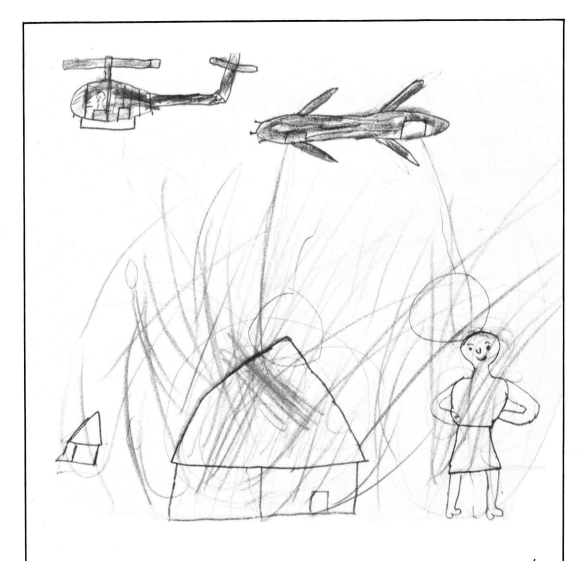

EStos son unos Abiones que andan Borbondiando por un conton de Jentes pobresitos que no tenion que comer

"These are some planes that go bombing a bunch of poor little people who have nothing to eat."

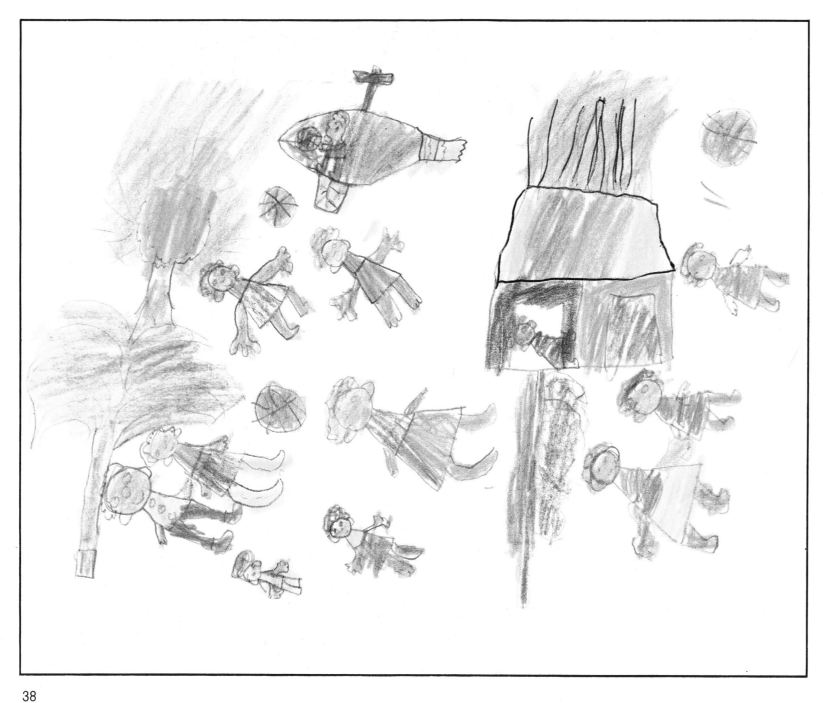

un abion andava tirando
bonvos y mato unos niños x
quemos unas cosas talves los
niños estaban emfermos y
tos mataron y la avion
andava Tirando por
todos los Lados adonde
axavon gente para matarlos
la gente se aesconderse
al monte x alli tos
allaron

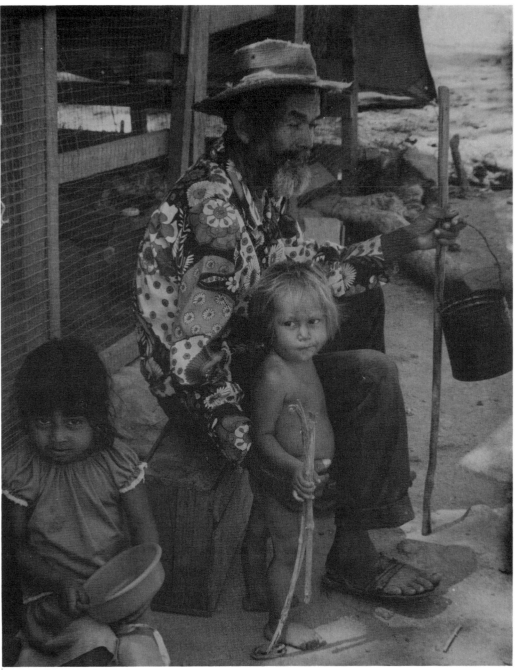

*"A plane was throwing bombs and
killed some children and burned
some houses. Maybe the children
were sick and they killed them and
the plane was shooting everywhere
there were people to kill. The
people went to hide in the forest
and there they found them."*

Renato Camarda

este dibujo indica delqueapasado
en el salvador lo queapasado en
nuestor pais es que masacraron
alos niños y ancianos y mujeres
en barasadas eso es lo que apasado
en el salvador. Poreso los
binimos ulledo por montañas
ille gamos aonduras ycuando
llegamo alos refugios los
recivieron muy vien por la
bulunta de dios oy no
sufrimos ya no andamos
como andavamos en el salvador
soy un niño que estudia
segudo mivel

"This drawing indicates what has happened in El Salvador. What has happened in our country is that they massacred the children and old people and pregnant women, that's what happened in El Salvador. That's why we fled through the mountains to Honduras and when we got to the refugee camps they received us well. By the will of God today we don't suffer and things aren't like they were in El Salvador. I am a little boy in the second grade."

W. Vornberger

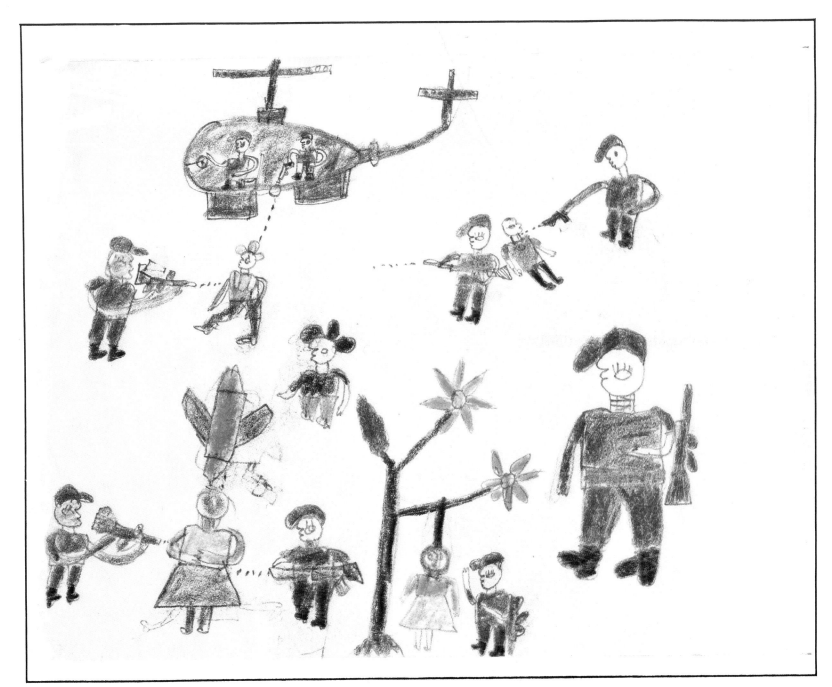

T H E F L I G H T

Children who survived the Lempa River massacre of March 1981, drew the pictures in this section. A U.S. Capuchin priest, Reverend Earl Gallagher, and an international worker, Yvonne Dilling witnessed the attack. Salvadoran helicopter gunships fired machine-guns and rockets at the refugees as they tried to cross the river from El Salvador into Honduras. Children clung to Father Gallagher's beard as he swam them to safety and Ms. Dilling tied infants to her bra straps to ferry them across. When the shooting stopped, over 200 people were dead or missing; many bodies were never found — washed away by the river.

The following is an account of the massacre by Ms. Dilling: "The helicopter made swoop after swoop. This time, several people had remained in the river. Instead of running up the bank they had jumped into the water and were hanging on to the ledge of lava rock. Each time the helicopter made a swoop, they ducked under the water. The soldier in the helicopter was incredibly intent on killing people. Over and over again he lay a path of machine gun fire only a foot away from the people in the water. Once he swooped so low that he almost touched the tree tops above us. One little boy was killed. I saw him jump into the water with a arc of bullet holes in his back. He was flailing his arms, still trying to swim while blood was streaming all across his back. Then the water carried him downstream.

Suddenly a bomb exploded within six yards of us. No one was hit but the blast covered us with dirt, flying debris, leaves, twigs, and stones. Ramon next to me said 'She is bleeding, I think she must have been killed.' He was referring to an older woman on the other side of him who was holding a baby — probably her grandchild. A few minutes later he reached over to take the baby. The woman was dead.

The assault probably lasted about twenty minutes, although it seemed like we spent hours under that tree. We could see the soldier leaning out the open helicopter door during the swoop, straining to see where the people were. Then the helicopter rose, made a big turn, gained height and speed, and came back down to fire over the same ground.

Just to watch that cold blooded maneuvering sickened me. He came so close that the propeller shook the treetops and made the dust fly. Certainly the soldier must have seen that he was firing at women and babies. Some children panicked and ran but as soon as they did, the helicopter spotted them and turned for another round. I felt like live bait, especially with the children darting from one bush to another."

"A terrible thing happened there (the Lempa River).
I was with with my wife and three children, and we
were about to cross when the shooting started; and
then that lament, and that whimpering of the chil-
dren, and the shock of the mothers who couldn't find
where to go, as they burrowed into the rocks. We
were just waiting for death there. The cannon mor-
tars were coming down too. Since I was watching
my wife and my children. I didn't pay any attention
to the cannon mortars."

"....from three o'clock on, the helicopter passed over
us three times, firing machine-guns and bombing
terribly. During that afternoon, many children lost
their lives, and many older people fell that day too.
A little boat sank with six children when the airplane
fired its machine guns at it as it was being pulled
across the river."

Norberto, refugee from Mesa Grande Camp

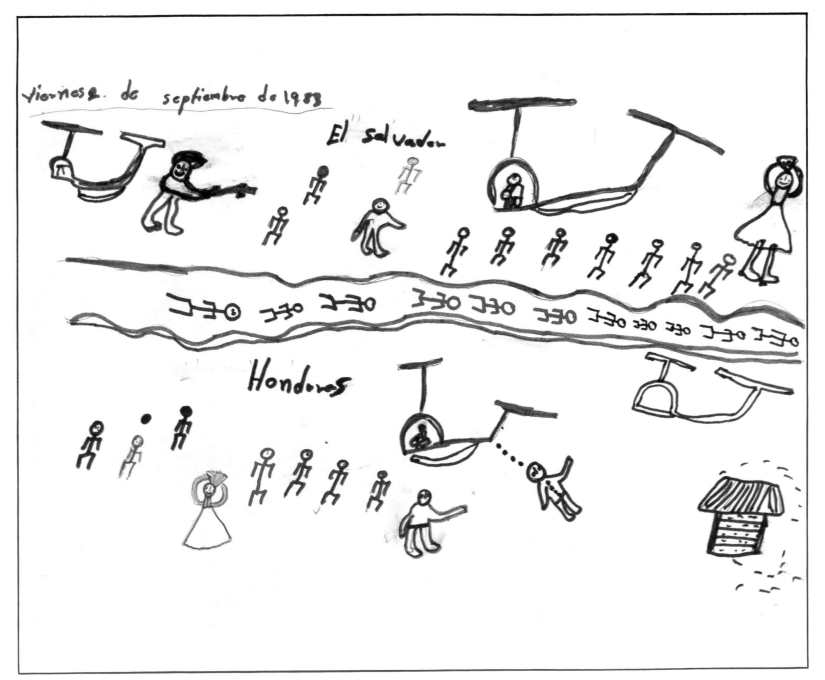

CARECEN

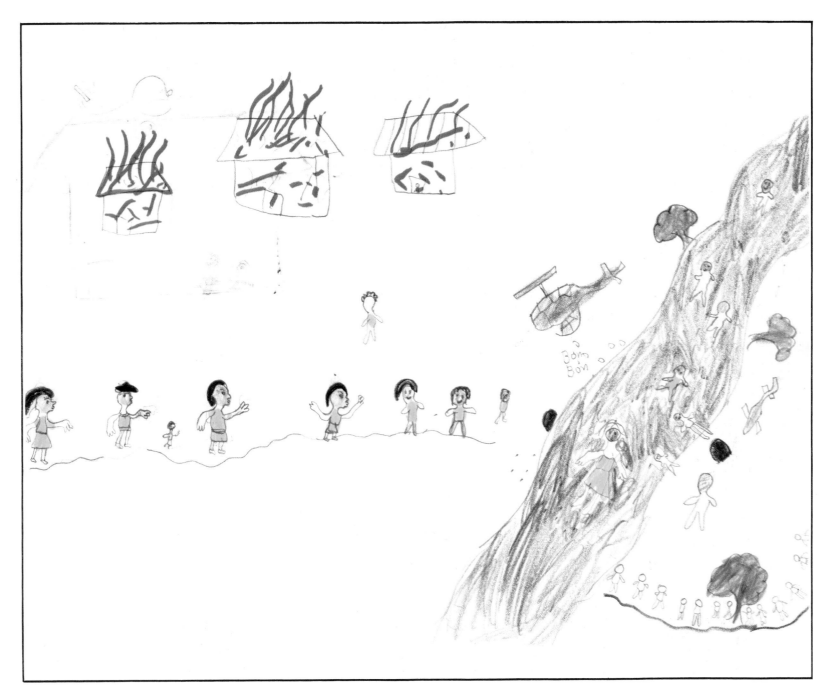

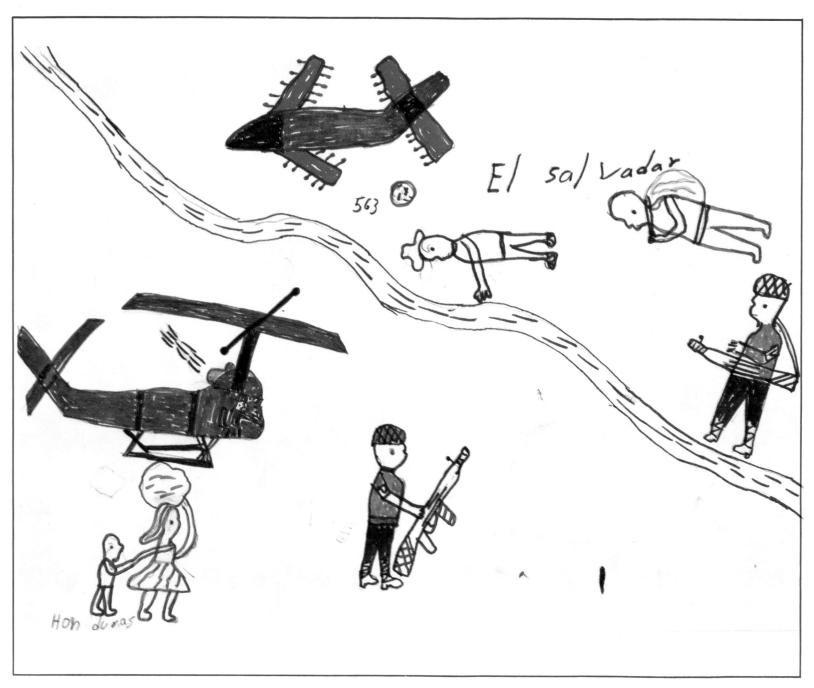

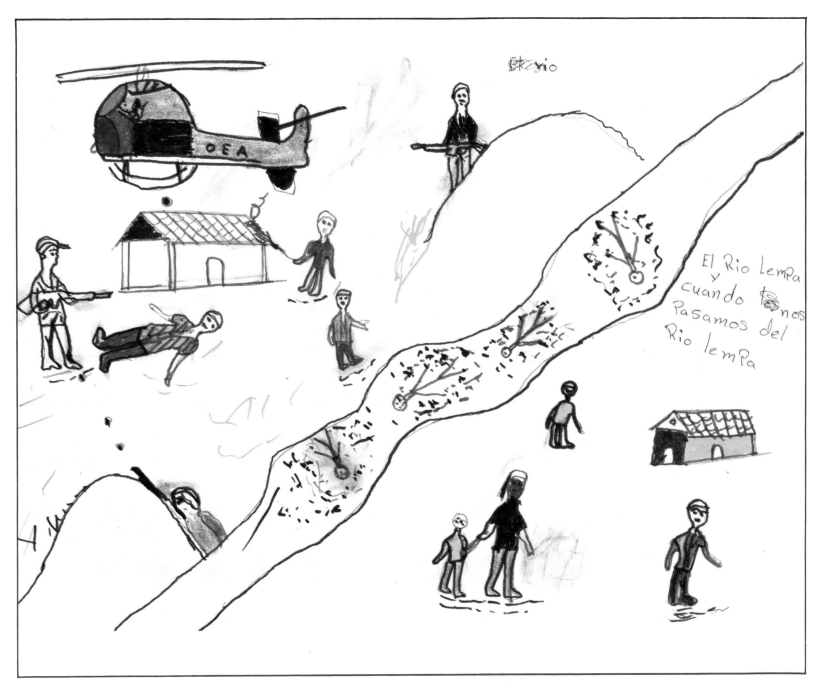

El Rio Lempa y cuando tenos Pasamos del Rio lempa

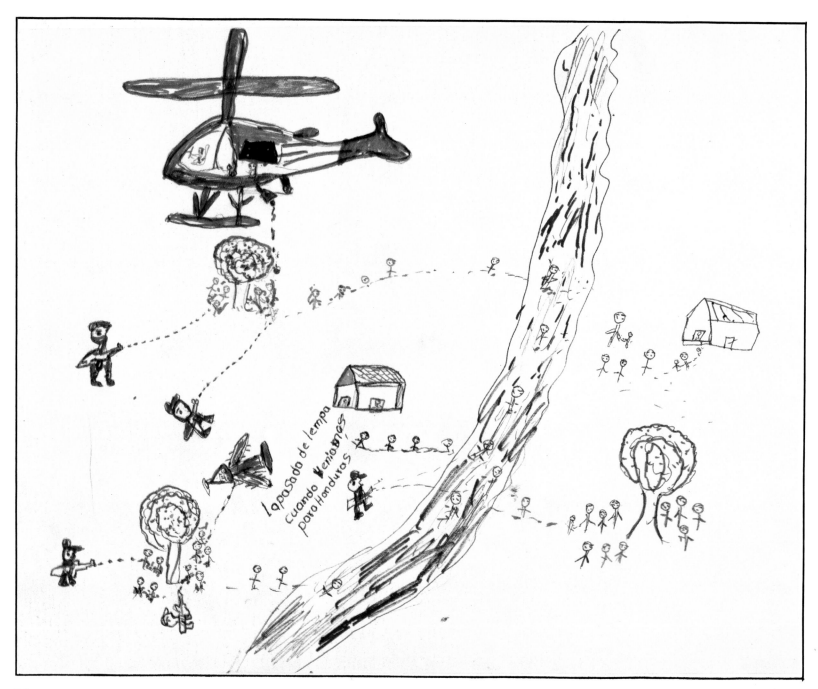

La pasada de lempa cuando veníamos para Honduras

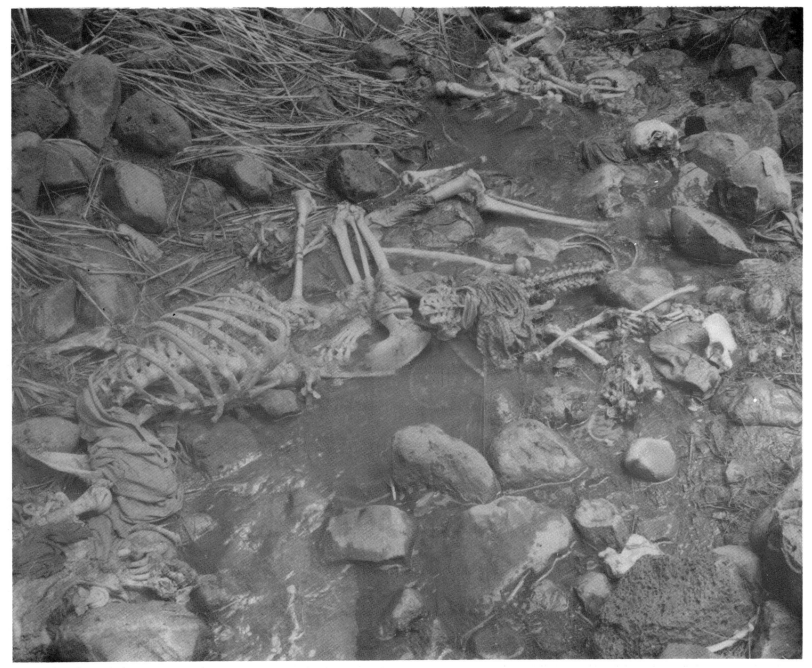

"I had the naked children clinging to me and a mother next to me frantically trying to make her child stop screaming. Everything around us shook. Machine-gun fire cut up a line in the earth as close as I'm sitting to you right now.

"We held hands and soothed babies for 20 or 25 minutes, while the helicopter tried systematically to massacre us all, riveting the river up and down, both shores with machine-gun fire, and then dropped some kind of mortar into the rocky banks.

"A priest was saying, 'Can you read anything on the plane?' With all that technology, it seemed odd that I could see the person looking out the window searching for us. I could make out specific facial characteristics."

Yvonne Dilling, international worker
at La Virtud and Mesa Grande refugee camps

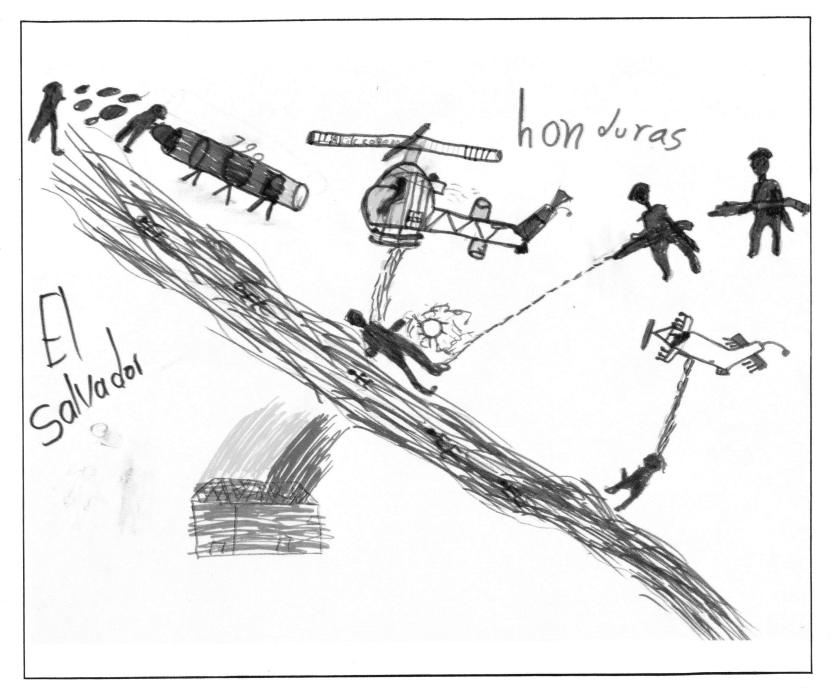

T H E R E F U G E

The civil war in El Salvador has caused over one million people to flee their homes. Many of these refugees still live in El Salvador, in 'displaced persons camps', while others live in United Nations sponsored camps in Honduras. Still others have sought refuge in Mexico, Costa Rica, Nicaragua, Belize, and the United States.

Living conditions for most of the displaced people are appalling. Many of these refugees are outside the scope of assistance provided by the Salvadoran government, the International Committee of the Red Cross, or the Catholic Archdiocese. They remain endangered by a military who considers them to be 'the enemy'. Thus many refugees continue to be kidnapped, murdered, or 'disappeared'.

The Lawyers Committee on International Human Rights and Americas Watch, in their report "El Salvador's Other Victims: The War on the Displaced" states that: "The Salvador government is responsible for military attacks upon the displaced and has violated their human rights. These actions appear to be regarded as legitimate steps in the Salvadoran military effort to defeat leftist guerrillas in the country.

"All the displaced in the government-controlled zones live in conditions of dire poverty compounded by malnutrition, lack of work and educational opportunities. Disease is rampant among the displaced, because of the inadequate health care, sanitation and water supply." Because of the conditions brought about by the war, many Salvadorans have fled their homes in search of refuge in other countries.

There are over 20,000 refugees living in United Nations sponsored camps in Honduras and although they receive sustenance food and health care, they live in constant fear and danger.

On August 29th, 1985 Honduran troops entered the refugee camp in Colomoncagua, Honduras and attacked the refugees. A three month old child was kicked to death by the soldiers, a 55 year old man was shot dead and another man died several days later of bullet wounds. Over 30 refugees were wounded and the military took 10 prisoners.

The Honduran government, with pressure from the U.S. and Salvadoran governments, has been trying for three years to relocate the refugees into the interior of Honduras. The governments claim that the refugees are not safe from the war in the border area. The refugees reply that their biggest fear is not the war but the Honduran and Salvadoran military.

The refugees believe that the governments want them to move because they want to station troops along the Salvadoran-Honduran border. The U.S. and Honduran military have held several 'war games' along the border and the Honduran army has, on numerous occasions, entered El Salvador in combined operations with the Salvadoran army. The refugees fear that once the area is cleared of refugees and international workers the Honduran military will move into the camps and establish bases there. They fear that it will be more difficult for refugees fleeing the war in El Salvador to reach the new camps.

This section shows scenes of a calmer, quieter time as well as children's happy faces. The refugees in Honduras and all Salvadorans want the war to end and for peace to return to their country. But they insist on a peace with justice. They insist that those responsible for the massacres, the death squad killings, the bombing of innocent civilians be held accountable. They insist that the conditions which have lead to this war — the poverty, the disease, lack of educational opportunities, inequitable distribution of wealth — be addressed and be amended. They want their society to be for the benefit of all Salvadorans. In this there is hope for the children who drew the pictures in this book. Only in a peaceful and just El Salvador can memories of fire from the sky be forgotten.

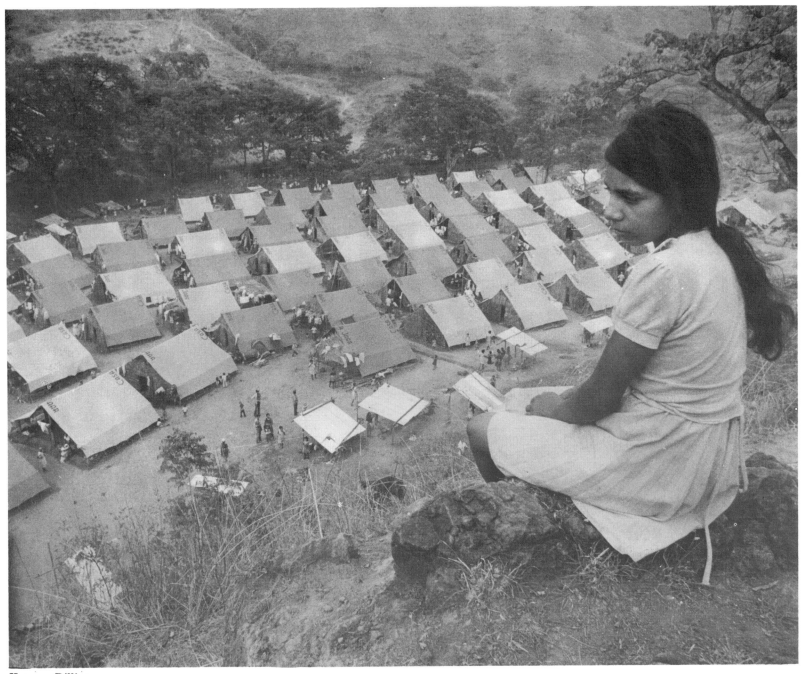

Yvonne Dilling

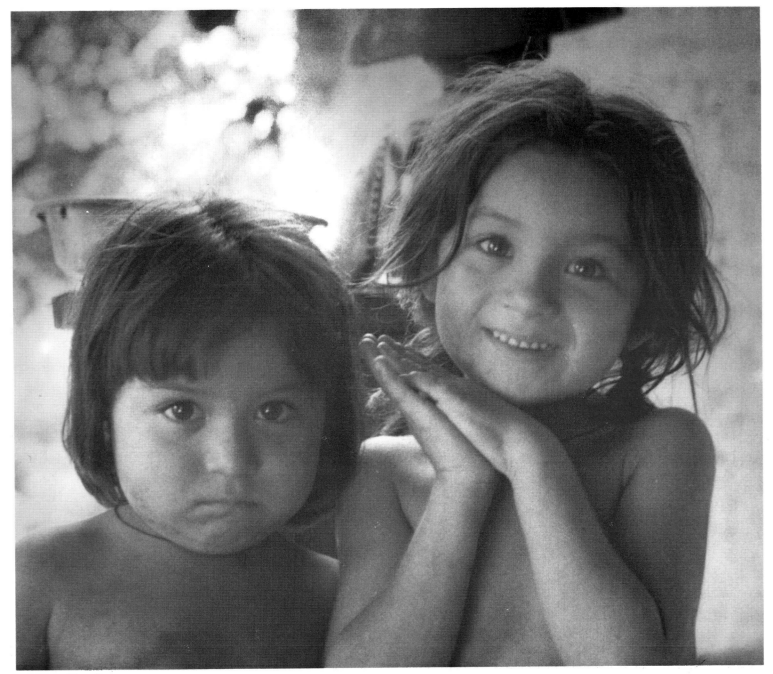

Wendy Shaull

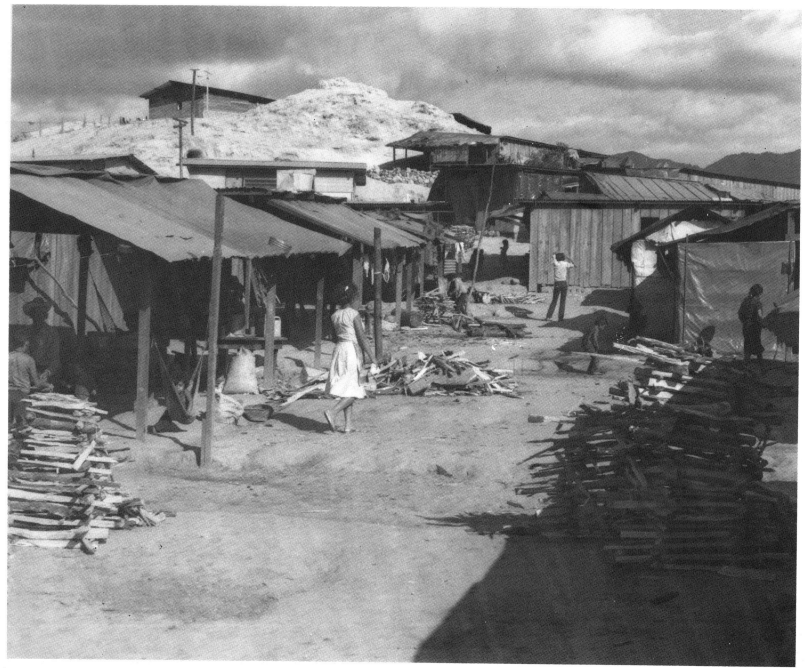

W. Vornberger

Firma

Firma Fermin Romero segundo ☺:-
Nivel

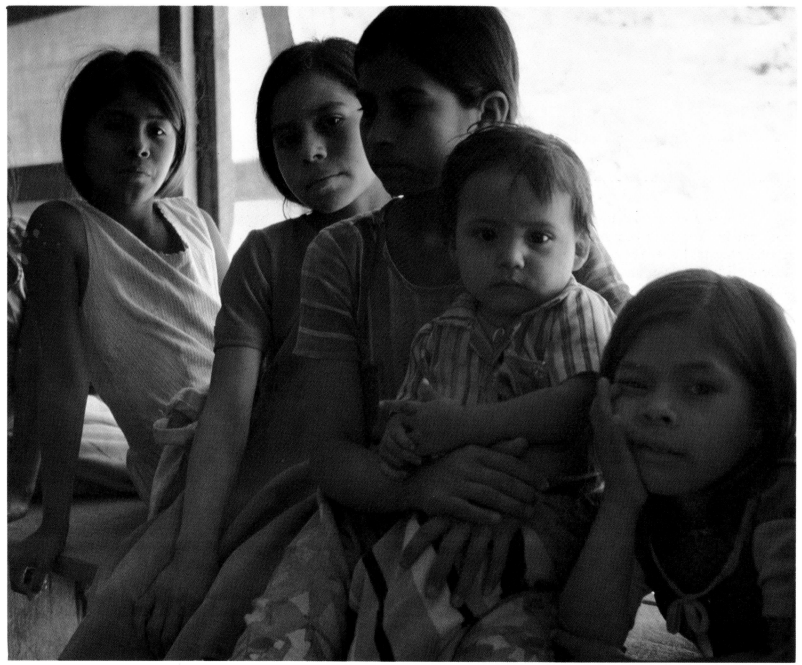

B. Lynne Barbee

A F T E R W O R D

The reader who will have gone through this book will by now be disheartened, indeed — the terrible sadness that seems endless: thousands of children living with the pain, the anxiety and fear and melancholy which these boys and girls have conveyed so powerfully in their drawings and paintings. We ought not forget what has happened to those young people, but we also ought not deny them hope — the possiblity that they can continue to grow, and somehow survive psychologically and spiritually the suffering they have experienced. In fact, if we fail to take into account that distinct capacity — which I have seen in children all over the world, no matter the humble and cruel circumstances they must take for granted — then we truly are walking away from them, consigning them to a "circle of the damned." These children have been damned — betrayed by all sorts of evil "principalities and powers." But they can still tell us, through words and pictures, what they have heard and seen, what a world of mean and callous and greedy people has done to them, among others. That capacity to document experienced loss, bereavement, brutality — that capacity to comprehend, to share with others, to reflect, is the essence of their humanity, of ours, too: we are the creatures who possess a consciousness, who share with others through words and pictures, who tell stories, and through such encounters with others, with ourselves, attempt to figure out what is right, what is wrong, what has happened, what ought to happen.

Suffering can be redemptive — so the Hebrew prophets remind us, and so the life of Jesus taught us. These children will never forget the murderous deeds they have witnessed; their scars will be part of their lives, no question — and part of all our lives, too. But these children have already shown their painful moral growth — their capacity and willingness to tell all of us what happened in the second half of the 20th century in a particular country. They have become moral witnesses of sorts, teachers for the rest of us. One only hopes and prays that we can prove ourselves worthy students of theirs — able to find ourselves morally responsive to them, to their predicament, which is, finally, that of all of us: what to do that will make this world more honorable and decent, less given to the kind of suffering and injustice which the people of El Salvador, among others, have experienced and continue to experience.

Dr. Robert Coles, M.D.